HOW TO RECOGNIZE

Gothic

ART

PENGUIN BOOKS

Author Dr Maria Christina Gozzoli
Idea and realization Harry C. Lindinger
Graphic design Gerry Valsecchi
Artist Fulvio Cocchi
Translators Erica and Arthur Propper

Contents

Penguin Books, 625 Madison Avenue, New York, New York 10022
Penguin Books Canada Limited, 2801 John Street, Markham, Ontario, Canada L3R 1B4

First published in Italy by Rizzoli Editore, Milan, 1978
First published in Great Britain by Macdonald Educational Ltd 1978
First published in the United States of America and Canada by Penguin Books 1979

Printed in Italy by Rizzoli Editore

Introduction

The period of the Middle Ages in Europe that spanned the twelfth to fifteenth centuries was one of profound economic and social change. Stable countries, united under strong monarchies, allowed a new social order to flourish of craftsmen, merchants, and bankers, who lived in expanding and prosperous cities. The clergy, too, enlarged its considerable sphere of influence. In art, the distinctive style of this period was the Gothic.

It is difficult to say where the adjective 'gothic' comes from, for the Goths were a barbarian tribe from Scandinavia who, being nomadic, did not develop any particular form of architecture, and as pagans did not build churches; nor is their influence evident in any other art form of the later Middle Ages. During the first century AD they moved southwards from the mouth of the River Vistula and settled on the left bank of the Danube. This area was not subsequently noted as a centre of Gothic art, so the word was not taken from the region where the style flourished. One likely explanation is that the Italian humanists of the Renaissance used the word Gothic as a synonym for barbarian, which to their way of thinking meant anything deriving from north of the Alps.

In architecture, the first Gothic examples appeared in the fertile and prosperous area to the north of Paris known as the Ile de France, a region in which a limestone was available for building that was both durable and easy to work. Between 1140 and 1144 the choir of the abbey of St Denis, near Paris, was rebuilt by an unknown architect who can be regarded as the originator of the Gothic style. From this time onwards it was in this style that French cities vied with one another in the building or rebuilding of their vast cathedral churches.

From the Ile de France the Gothic style was adopted throughout Europe. The French architect William of

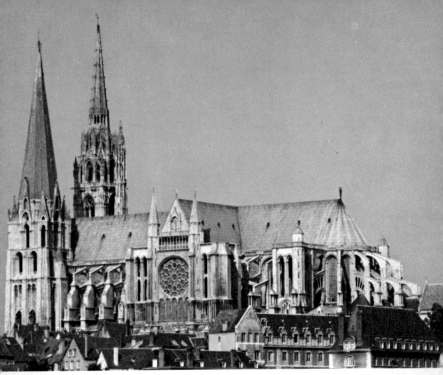

Sens started work on Canterbury cathedral in 1174; and Lincoln cathedral was begun in 1192, the cathedral at Wells in 1184, and Westminster Abbey in 1245. In Germany and other German-speaking countries, and also in Scandinavia and Eastern Europe, an adaptation of the style developed. In Spain and Italy the Gothic style was also employed; but here it lost its more distinctive characteristics and became blended with local architectural traditions.

There were variations not only from one region to another, but also between generations. In England, for example, church architecture passed from Early and Middle English through the Decorated style to the Perpendicular. Developments in sculpture, painting, and the making of stained glass, jewellery, tapestry, and illuminated manuscripts also varied. In all these arts, however, the distinctive and closely related forms of Gothic art remained truly international.

▶ Part of the Tower of London, built between 1086 and 1097 and subsequently enlarged several times at points including the part shown here. The Tower is a typical example of a castle-fortress. The central building is defended by a wall with thirteen towers, which is in turn surrounded by another wall with eight towers, and a moat.

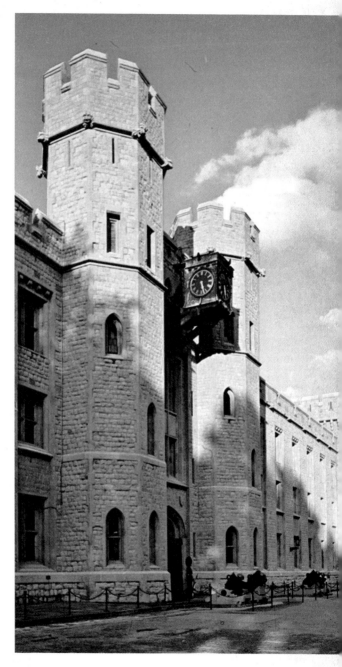

Architecture

Unlike the society that supported the rigid heirarchy of feudalism, that in which the Gothic tradition flourished was dynamic. The 'burgher' class of merchants and craftsmen lived in towns as free men and did not owe allegiance to a feudal lord. The centralization of power under strong kings in countries like France and England meant that commercial life was no longer disrupted by warring barons. As a result trade flourished and the growing cities became aware of the influence they could now wield. The power of the clergy was also conspicuous,

► In much ecclesiastical Gothic architecture, in the west front the main portal was higher than those on either side of it, and a great rose window dominated the upper part of the elevation. The relationship between the tall slender towers and the intermediate space was governed by precise and sophisticated proportions of considerable complexity.

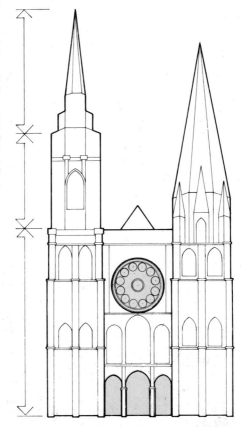

as bishops, abbots, priests, and monks sought, in frequent conflict with the nobility of the time, to extend their influence over the things of this world as well as the souls of their flocks. The Investiture contest, the dispute between Church and State over who should appoint bishops, was a major source of strife during this period.

Three main influences helped create the atmosphere in which the great Gothic cathedrals and churches were built. First, there was a genuine desire to glorify God and proclaim the Christian faith. Second, in the powerful cities the bishops and rich burghers felt a justifiable pride in 'astonishing and enchanting' the world with their immense cathedrals, towering above ordinary buildings

▶ The west front of Chartres cathedral. The two flanking towers give an impression of height but differ in shape and proportion. The northern tower, on the left, was begun in 1134, and a pierced, richly decorated steeple was added at the beginning of the sixteenth century, bringing the tower to a height of 115 metres. The southern tower, begun in 1145, is 106 metres high, its spire measuring 45 metres.

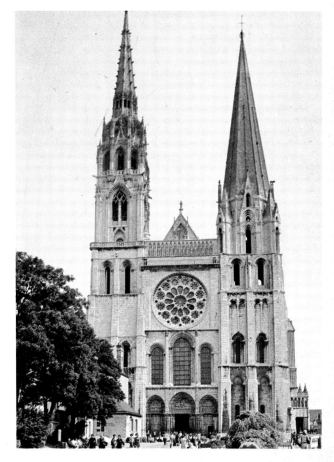

The structure

▶ The apse of the cathedral of Notre Dame de Paris, which was started in 1163 and completed during the thirteenth century. The slender flying buttresses, which carry the outward pressure of the vaults from within the building, form an aerial pattern of aspiring verticality.

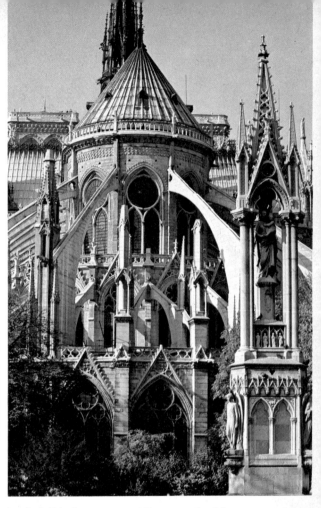

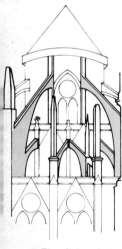

▲ The flying buttresses of the great Gothic cathedrals, despite their lightness of appearance, had a precise, stabilizing function. They transferred the lateral pressure of the cross vaults down to the buttresses which in turn supported them, and thence to the ground.

and visible from a great distance. And far removed from these worldly concerns medieval philosophy taught that it was not only possible to reach God through faith but also through reason. God could be reached by an effort of thought that was complex but refined, rigidly formal yet subtle.

It was these latter concepts which most inspired the architectural form of the Gothic cathedrals, whose verticality could be seen as an embodiment on earth of the ascent towards God. In form they were both complex and refined, formally rigorous yet rich in detail. Their common visual effect of an upward surge was achieved by means of a number of technical innovations, in particular

▼ Buttresses on Chartres cathedral. The flying buttresses, like bridges built into space, link the main body of the building to the external support of the vertical buttresses below. Several rows of flying buttresses, one above the other, help distribute the lateral pressure of the vaults, which is discharged by the uppermost flying buttress, partly onto the vertical buttress to which it is joined, and partly onto the flying buttress below.

the pointed cross vault, the use of pointed rather than round arches, and the use of flying buttresses.

To recognize a cross vault, imagine two cylinders each cut in half lengthwise and laid on a table. Disposed like this they can be taken to represent a tunnel, or barrel, vault, and, when arranged in the form of a cross, a cross vault. In a structure of this kind, the junction of the four vaults requires a pointed outline to each in order to make a neat join. The parts between the ridges forming these outlines are called webs or, sometimes, sections or partitions. The ridges themselves are called groins, and the point at which they converge, at the top of the vault, is the keystone.

Gothic architects, searching for new ways to achieve a greater general height, illuminated by larger windows, were not content with the restrictions of the groin vault. This type of vault had to be built over a square bay so that the two tunnels intersected at right angles. Its great advantage was that the groins carried the weight to the

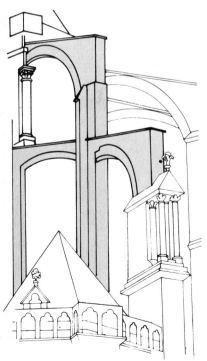
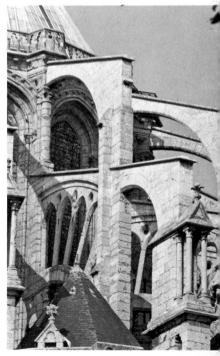

The main portal

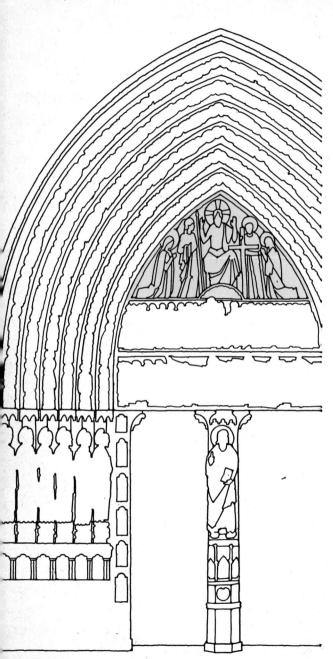

◄ The figure of Christ the Judge dominates the centre of this tympanum, sitting between Mary and St John and angels carrying the symbols of the Passion. Virtually all the available space is filled, and the central pillar, or trumeau, also has a statue carved on it.

► The central portal in the west front of the cathedral of Notre Dame de Paris. It is known as the Portal of the Last Judgment, from the figures on the tympanum, which were sculpted in about 1220. The porch provides an example of the harmonious union within the Gothic style of architecture and sculpture. It is divided into a number of deep embrasures cut obliquely into the thickness of the masonry and entirely covered with sculptures. The archivolts are decorated with angels and saints from the court of Heaven, while the bases carry figures of the Virtues leading man to Heaven and the Vices drawing him into Hell.

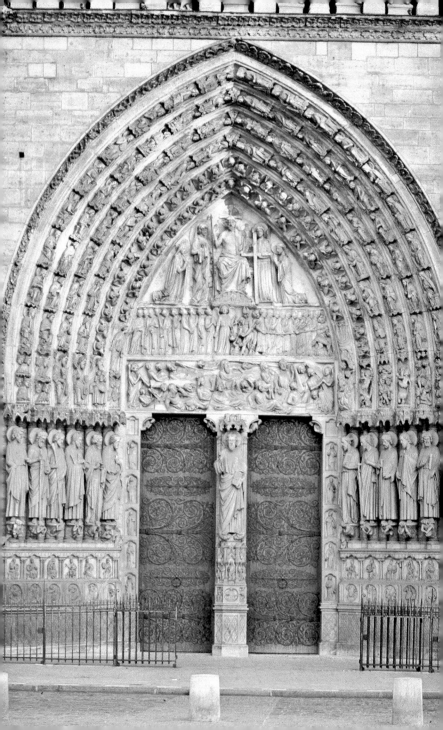

The rose window

▼ ▶ External view of the rose window in the west front of Chartres cathedral. The window is made up of three concentric circles, the middle one with delicate stone tracery, the outer containing a series of smaller circles. The structure is based on geometrical rules, precisely observed.

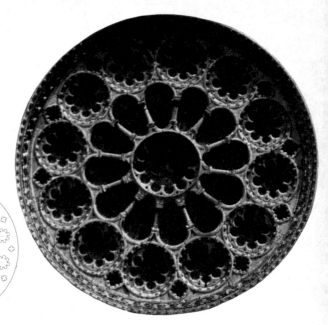

pillars at the four corners of the vault, leaving the wall spaces free from pressure. In due course an unknown master builder – as architects were called in those days – discovered that if he built a cross of ribs over the groins, he could fill in the webs between them to make a bay of more or less any shape. He also found that by making the arches pointed the keystones of both vault and arches would be the same height, giving a much smoother appearance. The ribs had all the strength of the groins, and carried the weight of the four corners of the vault. A cross vault exerts a strong pressure sideways as well as the downwards pressure absorbed by the pillars; and as the wall spaces were occupied by large windows, this sideways pressure was counteracted by flying buttresses, external arches that extended from the base of the vault to the wall buttresses of the side aisle. This construction ensured that the weight of all the architectural elements was carried from the keystone of the nave vault through to the outside of the building and its foundations.

The upward movement of the arches, pillars, and ribs, coupled with their slenderness, seems to defy gravity, a

► The rose window in the west front of Chartres cathedral, seen from the interior. The main effect is of the splendour of the stained glass as the light filters through it. This window was constructed between 1210 and 1220, when the cathedral was rebuilt after the fire of 1194.

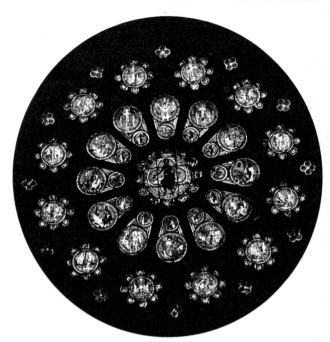

sensation which is heightened by the fact that those inside the cathedral cannot, and are not meant to, observe the laws of construction which are at work. Only when you walk around the outside of the building can you see the supports to the vault, in the form of the remarkable system of flying and other buttresses.

The seemingly miraculous aspect of these structures is perhaps the more appropriate considering the difficulties and sacrifices faced by the people of Rheims, Chartres, Paris, Amiens, Beauvais, and elsewhere throughout Europe so that these splendid 'hymns to God' could be constructed. Finances often came in the form of anonymous donations from thousands of citizens, and many contributed voluntary labour. In Chartres the citizens took the place of the exhausted horses and themselves pushed carts of building materials through the narrow streets to the cathedral site. There are many such examples of whole communities demonstrating their commitment to the building of a cathedral, with truly impressive results.

In its standardized aspects, the cathedral interior took

the form of a Latin cross, running from east to west, with the altar placed at the east end – towards Jerusalem. It was subdivided into three parts, the central part, the nave, being higher and wider than the flanking aisles, of which there might be sometimes as many as four. The nave was separated from the aisles by rows of pointed arches resting on clusters of slender shafts and half columns. Looking down the nave of a Gothic cathedral produces a breathtaking sensation of height. This effect is due partly to the actual height of the nave (in Notre Dame de Paris it is 35 metres high, at Rheims 38 metres and at Amiens 42 metres) and partly to the ratio between height and

▶ The ideas both of the Ca'd'Oro's intertwined arches and their so-called 'stretched bowstring' shape have been said to be of Oriental origin. But their graceful lightness is typically Gothic, even allowing that the Gothic style was less pure in Italy than elsewhere.

width, for the relative width of the nave was invariably limited. At Chartres, the ratio is 1 : 2.6, in Notre Dame de Paris it is 1 : 2.75, and in Cologne cathedral it is 1 : 3.8. At Beauvais this striving towards an effect of impressive verticality was the undoing of the architect of St Peter's, where in 1272 the vaults were erected at a record height of 47.5 metres, and in 1284 collapsed.

The shorter part of the cross, the transept, separated the nave from the choir and the high altar. The transept itself was usually subdivided into three aisles and projected a little on either side beyond the longitudinal part of the cathedral.

▶ Detail from the upper loggia in the palace of the Ca' d'Oro, Venice. The influence of Islamic art, exercised in Venice as a result of close trading relations between the Most Serene Republic and the Orient, is pleasingly intimated in this example of Venetian Gothic, built between 1421 and 1436.

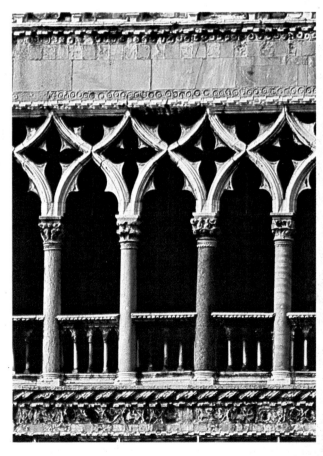

The vaults

▶ The absence of decoration shows up the Gothic 'skeleton' of this thirteenth-century cross vaulting. Each transverse arch rises from the capital of a half-column built against the wall, and defines the vault, as well as the ribs which support its weight and divide it into triangular sections.

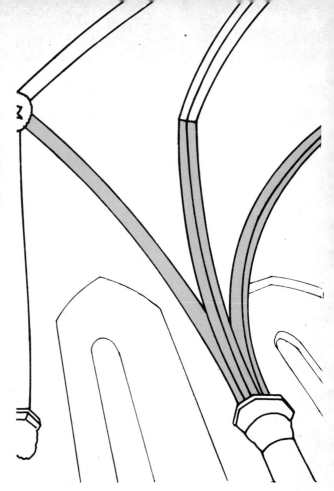

A transept with massive façades, often flanked, like the main, west, front, by towers and containing large decorated doors, was a characteristic feature of Gothic cathedrals. The cathedral at Chartres, for example, has nine doors – three on the west front and three, half-hidden by splendid sculptured arches, in each of the transept's north and south façades.

The development of the choir in Gothic cathedrals took an innovatory course. The lateral aisles were extended across the transept and round the back of the high altar, forming a wide passage called the ambulatory. The grandeur of the choir was also enhanced by a number of chapels leading off the entire length of the ambulatory.

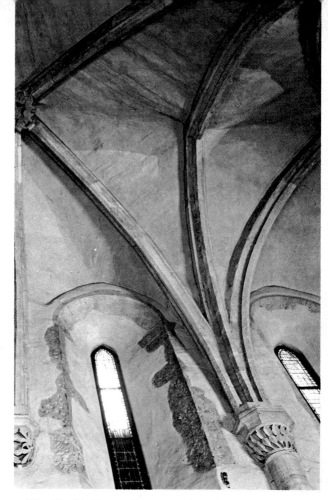

▶ Details from the vaults of the Synagogue of Prague, built about 1270. In the economy of its forms and the absence of decoration, the building is reminiscent of the Gothic architecture of contemporary abbeys and convents.

The Gothic form of construction, by transmitting the weight of the church across pillars and buttresses to the ground outside, ensured that the walls no longer functioned as supports and could therefore be safely filled with large windows and arches. The windows became a light framework, pierced to provide spaces for stained glass – an exclusively Gothic invention. If the walls were removed from a Gothic building the essential structure of pillars, vault ribbing, and buttresses would remain intact – unlike modern buildings constructed from blocks of reinforced concrete. Indeed, from the interior of the church the walls are scarcely noticeable. On either side of the nave in a characteristic Gothic cathedral were

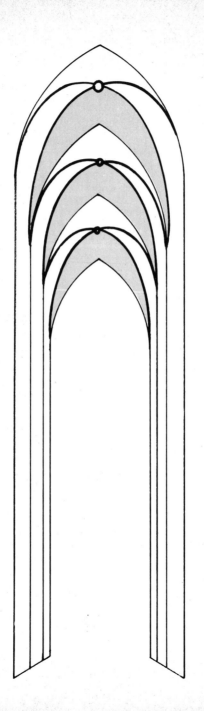

◀ The exceptional soaring effect of Gothic church architecture seen from inside tends to be accentuated by its extremely narrow proportions. The drawing shows the line of the ribs which converge at the summit of the pointed cross vault.

▶ A view of the interior of Cologne cathedral. A strong other-worldly effect is conveyed by the limited width of the central vessel in relation to its height — 1:3.8, the narrowest proportion of any cathedral church. The vertical clustered shafts of the pillars emphasize the appearance of upward thrust, which is unhampered by horizontal elements such as capitals or projecting cornices.

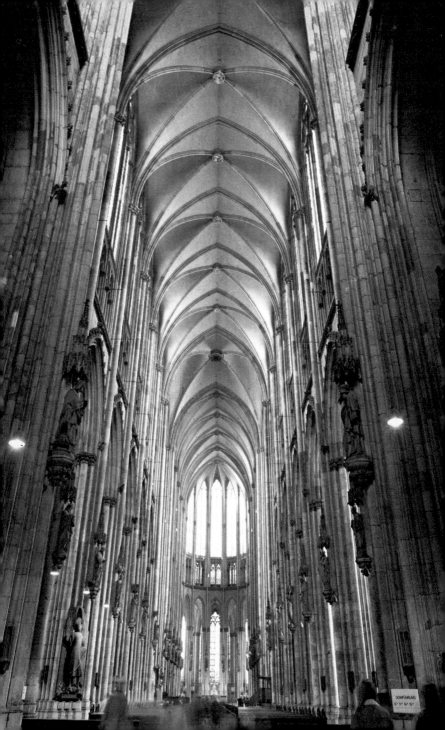

The nave walls

▶ As Gothic cathedral walls had a limited function as a support, the structural stonework tended to be reduced to an essential minimum. The lower part of the nave was bounded by a series of soaring pointed arches and the upper part by a gallery, or triforium, of arches, supported on small, slender pillars and surmounted by large stained-glass windows.

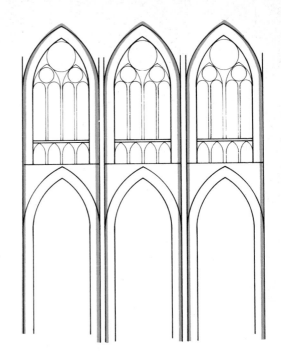

delicate pillars with pointed arches. Above these a small gallery, or triforium, opened onto the upper part of the nave through pointed arches usually divided into three parts – hence its name – which were supported on small pillars. Frequently, as in Cologne cathedral, the triforium lay above the roof of the aisles and its outer wall was pierced, providing an extra light source.

In the upper part of the church and throughout the choir, light was also admitted through vast windows of stained glass depicting various figures. The windows were usually mullioned; that is, subdivided into two or more arches supported by small slender pillars. The upper part of each window featured a pierced circle, usually with a foiled ornament. The stained glass of Gothic church windows had intense, brilliant colours in which mostly blue, ruby-red, violet, and emerald green predominated. The effect of the light as seen through these windows, casting diffuse colours over the interior of the church, was mysterious and awe-inspiring, and, like the breathtaking contrivances of the construction itself, was intended to

▶ A wall of the nave of Cologne cathedral. The nave itself was rebuilt in the nineteenth century, but faithfully reproduces the essential elements of the Gothic style. The clustered shafts of the pillars support statues of the Apostles under canopies. It is clear that the pillars are the wall's only forms of support. Arcading, triforium, and stained-glass windows merely serve to partition off the nave and aisles below, and the interior and exterior above.

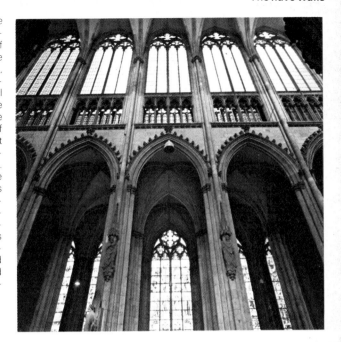

provoke in worshippers a sense of the other-worldly. The use of stained-glass windows was seen as a decoration appropriate to God's house, and a means of proclaiming the glory of God.

But the stained glass of the huge windows, decorated with figures illustrating Bible stories, also had an educative purpose. They served as a means of preaching the Gospel to 'simple people who do not know the Scriptures in which they should believe', as one medieval monk put it, and for a populace who could not read they provided pictures, rather in the manner of a comic strip or a cartoon film. The transparency of the glass itself heightened the suggestive power of the episodes depicted, for it helped symbolize the Christian belief that light, along with the other gifts of Nature, comes direct from God.

The typical exterior of a Gothic cathedral displayed the same characteristics as the interior – lightness and verticality, a reaching towards the sky. These effects were secured by offsetting all horizontal lines and shapes with

vertical ones. The compactness of the external walls was broken up by a series of portals, windows, arches, and statues, so that the empty spaces predominated and an effect of ethereal lightness was achieved. Towers on either side of the west front reinforced the impression of upward thrust. This arrangement was particularly characteristic of the Ile de France, where it is found on every cathedral. The towers, which incidentally housed the bells, usually terminated in cone-shaped or pyramidal spires whose delicately pointed outlines were a culmination of the whole building's vertical appearance.

The front elevation of Notre Dame de Paris embodies all these principles perfectly. Horizontal cornices divide it into three planes, and at ground level are three recessed portals which break up the solidity of the walls, and embrasures richly decorated with friezes and other sculpture. There are three large windows in the central plane, and a sizeable rose window dominates the upper plane. The central door and window are taller than those on either side, and are divided from them by pillars in relief. These, as well as counterpointing the horizontal cornices, thus reproduce the internal arrangement of nave and aisles, to establish a perfect equilibrium.

Typical features of Gothic architecture include, in particular, the rose window. Its circular shape, divided by delicate ribs of stone like the spokes of the wheel, was an allusion both to the sun, the symbol of Christ, and the rose, representing the Virgin Mary. As a source of light, especially in the area of the high altar, it could, in sunlight, produce dramatic effects of colour; and on the building's exterior its elegant tracery had the effect of lightening the surrounding façade.

On the west front, the facade of a cathedral in the Gothic style typically featured a gallery of pointed arches supported by slender columns and serving to link the two flanking towers. This lightened the appearance of the stonework, and was also sometimes used to provide a series of niches for statues. Towards the summit of the building's exterior, meanwhile, and above the nave, the roof was strongly sloped. Flying buttresses joined its highest part to the other buttresses and the roofs of the aisles. The angle of the flying buttresses could be slanting or perpendicular according to the relative position of the aisle wall on each side of the building, and the number of

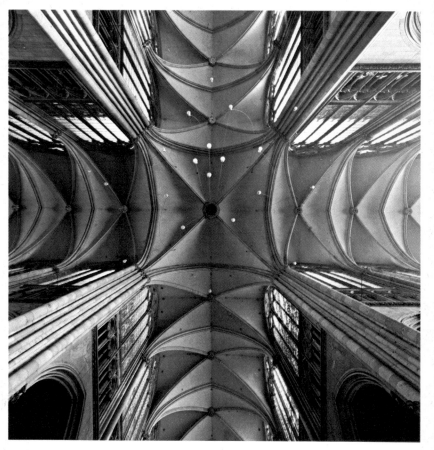

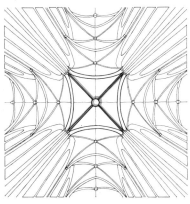

◀ ▲ The roof of Cologne cathedral at the intersection of nave and transept. Note the strict geometrical regularity, a feature of the Gothic style. This is a particularly lively and complex play of architectural forms, each half-column of clustered shafts continuing into the structure of the vaults.

rows in which they were arranged could also vary. Often these rows were disguised by pinnacles rather like miniature towers, or by small steeples decorated with carvings of leaves, flowers, and buds, and other plant motifs. In appearance, the purpose of these diminutive spires was to emphasize the building's upward thrust and to add an effect of lightness and grace. Their true function, however, was to exert downward pressure at the point where the flyer met the vertical buttress, and to prevent the latter being pushed outwards. In the uppermost flying buttress, too, a groove was incised to channel rainwater from the roof of the nave to the imaginatively carved drainpipes known as gargoyles.

Although profane imagery is commonly seen in Gothic churches, the inspiration behind both the architectural structure and the sculptures – the large statues, the low reliefs and the decoration of the steeples, pillars and buttresses – was mainly religious. The effect of these sculptures was almost that of a large pictorial encyclopedia in stone. Religious themes, taken from both Old and New Testaments, included saints, prophets and other figures with their identifying symbols – St Peter with his keys, St Barbara with her tower, St Margaret and the dragon, Jonah and the whale – and also narrative cycles such as the Life of Christ, which was usually placed over the central door of the west front.

Favourite among profane subjects were the seven liberal arts: a little switch symbolized grammar; a blackboard, rhetoric; hair enclosed in rings, or sometimes a scorpion or serpent, dialectic; an abacus, arithmetic; a compass or pendulum, geometry; a sphere or sextant, astronomy; a lute, music. The months of the year were often represented in terms of seasonal agricultural pursuits: grafting of trees, harvesting, slaughtering the pig, and so on. The signs of the Zodiac and even historical events were also sometimes illustrated; and some French cathedrals carry a 'Gallery of Kings', showing the French monarchs from Charlemagne onwards.

The statues that decorated the exterior of a Gothic cathedral conformed to the same principles of verticality and upward thrust that were expressed in its structure. On the Royal Portal of Chartres' west front their stance is rigid, with arms close to the body, straight legs, and

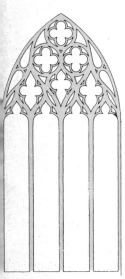

▼ This cathedral window in a late form of Gothic is divided into four parts by sharply outlined shafts terminating in tri-lobed arches. The upper part is an elaborate geometrical trellis of rhomboids and polylobed arches.

▶ One of the 176 windows of Chartres cathedral in a late style of Gothic — it was inserted into a thirteenth-century wall in the course of the fifteenth century. The vertical arrangement of the scenes depicted emphasizes the upward thrust of the whole composition. The scenes are religious in content, intended to instruct the congregation. Sunlight passing through these brilliantly coloured windows has the effect of filling the interior with richly transmuted radiance.

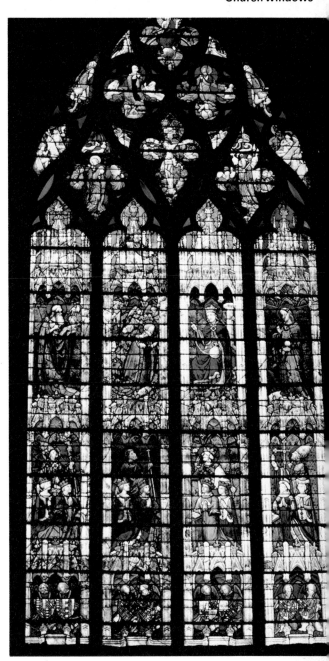

▲ The development of the transept is a characteristic feature of Gothic cathedrals. It is often subdivided into aisles, and its great façades, facing north and south in each case, are characteristically decorated, incidentally or otherwise, by large portals, arcading, statues, and one or more extensive rose windows.

drooping feet. The folds of their clothing drop in rigid parallel lines like the fluting of a column, accentuating the elongation of the figure and its lack of hips and shoulders. Usually the heads were small in relation to the bodies. The expression of spirituality and beatitude on the faces was emphasized by long eyes and fine, gently smiling lips. The figures were each accompanied by an overhead canopy and a carved base, which formed a niche and provided a further link between the sculpture and the building as a whole.

Another decorative feature of Gothic architecture was the ornamentation of the portals. These were recessed, with numerous deep embrasures cut obliquely into the thickness of the stone. The lower part of each embrasure contained a statue, while the upper part, corresponding to the archivolts (the mouldings which follow the contour of an arch), was carved with a series of low reliefs or statuettes. The central pillar, or trumeau, which divided the doorway also served as a support for a statue. In the later Middle Ages the decorative carving in the areas around the portals took its motifs from nature. Carvings representing rose bushes, strawberries, ferns, vines, oak,

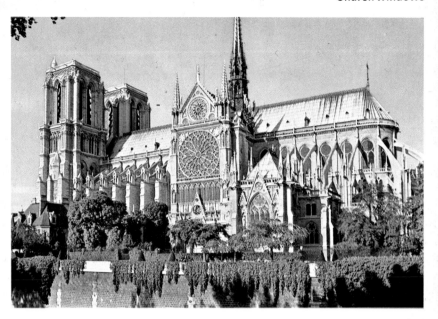

▲ The southern aspect of Notre Dame de Paris. The transept, begun by Jean de Chelles in 1258 and completed about 1270, is an integral part of the building's longitudinal body. Its façades are extensively pierced, having two rose windows facing each other, the larger of which measures 13 metres in diameter.

and maple leaves were all executed with great refinement.

The great cathedrals were probably the finest achievements of the Gothic architects. But the master builders of the time also had patrons other than the bishops and rich cities who sought to glorify God by erecting new churches. They undertook commissions from the monastic orders, particularly the powerful Benedictines and Cistercians, and built fortresses and palaces for nobles and kings.

For the conventual churches of the Gothic period the architectural concepts were the same as for the cathedrals. The ground plan was in the shape of a Latin cross, the relationships and proportions had the same tendency to the vertical, and the system of construction used pointed cross vaults and arches, and flying and other buttresses. Cistercian monasteries, however, were usually established in isolated places far from towns. For this reason, and also because of Cistercian rules of austerity, there was a minimum of decoration. The church, usually linked to a square cloister and the conventual buildings, was almost completely unadorned and had no sculpture.

All the features of medieval architecture so far described

27

Church statuary

were of course at some point modified or enhanced, both both in local variations and by the continual changes within the Gothic style that took place over the centuries when it was internationally supreme in Europe.

Geographically, the Gothic style varied not only from one country to another but between districts – and this in spite of the fact that many of the master builders and craftsmen of the period often worked outside their own country – for example William of Sens, the French architect who undertook the building of Canterbury cathedral, and Barnard Flower, from the Netherlands, to whom are attributed the superb stained-glass windows in the parish church at Fairford, in Gloucestershire. To take one English example of these local differences: in the counties of Leicestershire and Northamptonshire church towers tend to have tall, slender spires, while churches in Somerset mostly have no steeple, but instead a tall tower with narrow rectangular faces. Local materials, too, often had a direct effect on the form of buildings. In parts of East Anglia, where flint was the only building stone close at hand, exterior wall space on churches was arranged to accommodate a unique form

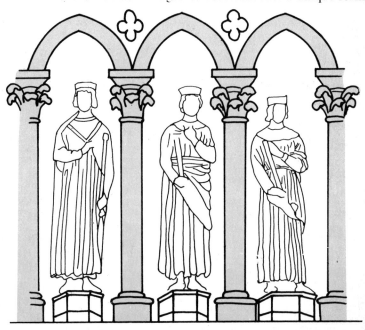

▼ On the south side of Chartres cathedral these statues of kings are, in their tall, narrow forms, characteristic of the time, and an example of the close relationship in the Gothic style between architecture and sculpture.

of decoration known as flushwork – as for example at Woodbridge in Suffolk – which displayed ingenious patterns using dark, shiny flint to eke out the available white cut stone.

Chronological developments in the Gothic style throughout Europe were very numerous and often varied greatly – too much so for many to come within the scope of this book. The problems in identifying Gothic architecture include the fact that many buildings are each an accumulation of styles. Often it is a question not of identifying, say, a Gothic church built as a whole – though these do exist: for example Salisbury cathedral was built in a uniform style – but of recognizing the Gothic elements within a building that may have such variations as windows of one date set into a much older wall (see p. 25). Other mixtures of styles may take forms such as the juxtaposition of the Late Gothic cloister and the much earlier cathedral church at Gloucester, or the addition of the ornate Middle Gothic Lady Chapel to Ely cathedral, where the main body of the church was begun centuries earlier in the Romanesque style that preceded any form of Gothic.

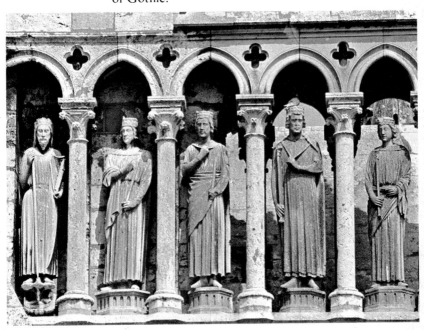

Church statuary

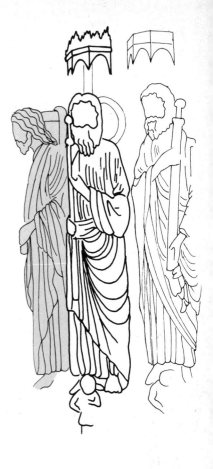

▶ Detail from a group of columnar statues forming part of a large portal. They are sculpted in high relief, and closely linked with the overall architectural structure, largely through the figured pedestal and poly-lobed canopy which frame each figure. Despite the apparent uniformity of the figures, there is a slight variation of gesture and facial expression. The central figure turns towards the door itself, continuing the inward movement of the portal.

▶ These slender, subtly variegated statues stand in the central portal on the south side of Chartres cathedral. They were sculpted between 1210 and 1220.

In more recent times, mostly during the middle and late nineteenth century, the Gothic style has been widely imitated, or used as a source of inspiration, in many parts of Europe. In church architecture, where this is particularly so, there are several ways to identify such work. In the case of whole buildings, as opposed to piecemeal alterations to surviving medieval structures, the uniformity of style may itself show a church to be neo-Gothic. This is especially true of buildings sited at any distance from a town centre or village dating at least from medieval times. Another indication that a church is in fact a nineteenth-century version of Gothic is sometimes shown by its deviation from local styles. At Marlow, in Bucking-

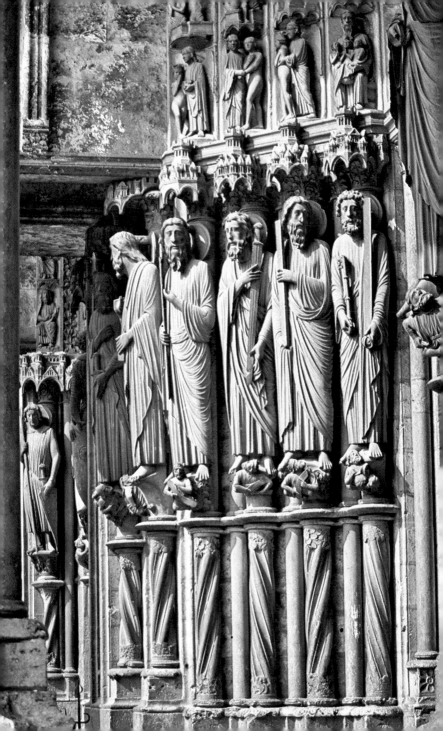

hamshire, the parish church, built in 1852, looks authentically Middle Gothic – but in the style of the East Midlands, with a particular shape of spire, rather than with the Late Gothic squat tower, often of brick, so characteristic of the middle Thames valley. Many such imitations are undoubtedly impressive in their own right; but most successful versions of the Gothic tend to be those genuinely of the Age of Faith.

The techniques of ecclesiastical architecture served as a model and stimulus for other forms of building, such as castles, houses, bridges, guild and city halls – which were

▶ Throughout the Middle Ages stone and brick gradually replaced wood as the main building material, and by the fifteenth century had superseded it almost completely. Houses faced the street, with high narrow frontages topped, especially in inclement northern climates, by steeply sloping roofs.

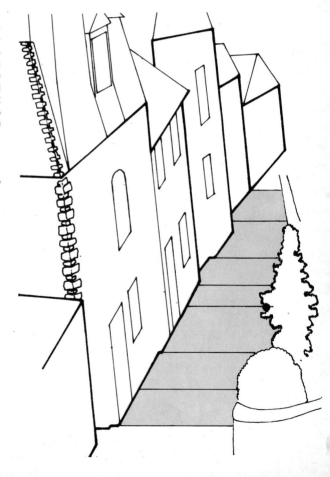

often graced by a high tower – and hospitals commissioned by charitable organizations. The sites of these buildings were usually within the fortified walls of towns whose winding, narrow streets followed the contours of the ground, producing varied and irregular layouts. In the construction of houses, especially those of the nobility, wood was gradually replaced by stone as the major building material. As was often necessary in those days, houses might be fortified. They tended to open directly onto the street via their narrow end, in which there was often a decorative entrance. At ground level an

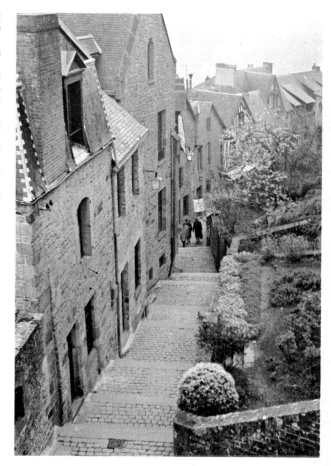

► A street on Mont St Michel, off the coast of Normandy. Medieval towns were generally enclosed by high walls and their layout was irregular. Streets were narrow, winding, and steep as they either followed the natural contours of the ground or formed short cuts between other streets. The houses tended to be built on high ground for purposes of defence.

arcade provided space for shops and store-rooms; and on the floors above there was living space for the families of the better-to-do.

An outstanding example of secular Gothic architecture is that of the Palace of the Popes at Avignon. This comprises the austere Old Palace, built for Benedict XII by Pierre Poisson, and the more elegant New Palace, which was built by Jean de Loubière for Clement VI. It had been intended to be light and graceful in a manner more closely resembling that of a cathedral, but because the popes often had to defend themselves by armed force, the architects had to design a fortress rather than a dwelling place. It has massive battlements, and small embrasure-like windows to maintain the protection afforded by the solid masonry. But a feeling of upward movement is imparted by large pointed niches and, at each of the four corners, a tower. The most important of these is the Angel Tower, which served to protect the papal apartments themselves. There is also a splendid cloister, around which were grouped the rooms for the papal household, and the chapel. These rooms, with their

▼ The Palace of the Popes at Avignon. The Old Palace and the New Palace are here respectively on the left and the right.

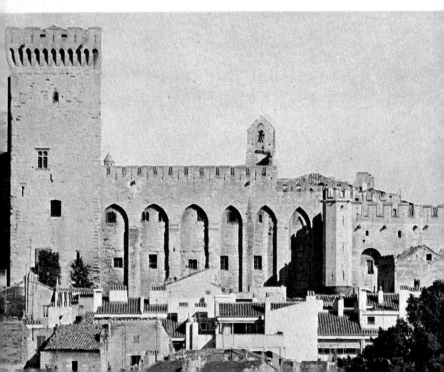

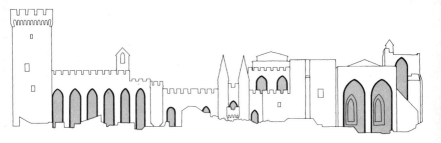

▲ Within the Palace of the Popes the Old Palace, built for Benedict XII, looks uncompromisingly like a fortress, with its high walls and square corner towers. The Angel Tower, on the far left, housed the papal apartments, the most sumptuous rooms in the building. The more elegantly fortified New Palace, to the right, was built for Clement VI between 1342 and 1352. The contrast between the windows at opposite ends of the building underlines the different purposes of the building's two main parts. Those in the Old Palace are small slit openings, set high up, and well protected. Those in the New Palace are larger and lighter, more like cathedral windows, and have no battlements above them.

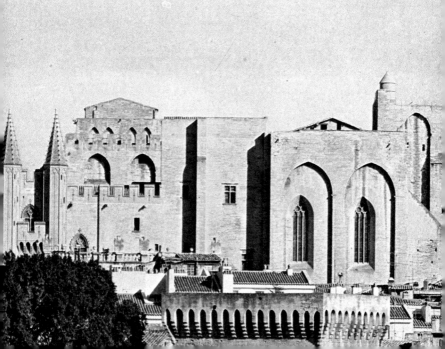

Secular Gothic

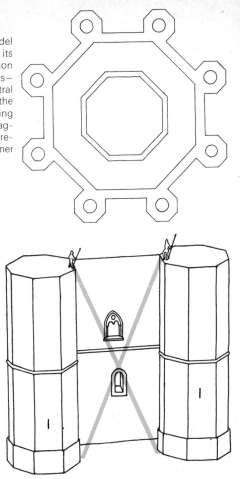

► Plan of Castel del Monte, showing its basis on an octagon repeated outwards – from the central courtyard to the strong surrounding walls, to the octagonal towers that reinforce each corner of the perimeter.

▲ Gothic military architecture was usually contrived so that the position of the towers afforded a good all-round look-out, and a double line of fire against attackers at their base.

frescoes, their sculptures, and their general effect of sumptuous elegance, provided a forceful contrast with the military aspect of the building. Within, it was a luxurious palace; from without, a fortress.

For military purposes, the architecture of the time obviously had to satisfy practical rather than aesthetic requirements. Defence was a passive business, conducted from behind fortifications made up of high towers, crenellated bastions, walls with walkways for guards, and slit windows to give protection for crossbowmen and other defenders who poured down burning oil or pitch on attacking forces. Of particular interest, and a good

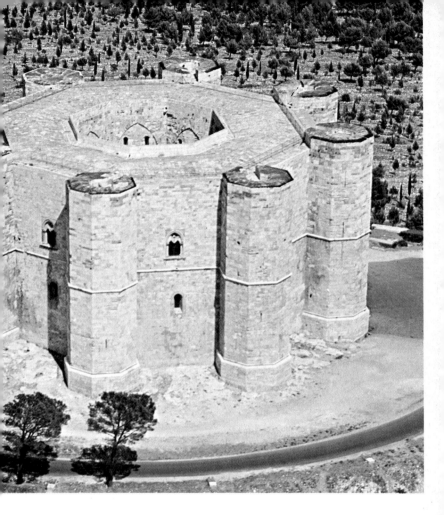

▲ Castel del Monte, in Apulia, was built as a fortified hunting lodge for the Emperor Frederic II in about 1240. Its powerful mass dominates the surrounding country.

example of military architecture from this period, is the Castel del Monte, in Apulia, a fortified hunting lodge built for the Emperor Frederic II. It was constructed on an octagonal plan around a courtyard, with a tower, also octagonal, projecting from each corner so that would-be aggressors might come under a two-pronged attack. In each of the eight walls, a window divided into two lights provided a look-out post over the surrounding countryside.

Sculpture

Gothic sculpture was largely created for use or adornment in the churches of the time. It featured, mostly as detail, on capitals, screens, fonts, and portals, and above all as monumental figures.

Most Gothic monumental sculpture is to be found on the outside of the cathedrals, rather than in the interior. It is commonly distinguished by its vertical, static effect, particularly in the elongated shape of the figures, their rigid posture and the stylization of their clothes. Any element of movement is usually provided by the heads, which incline forward or back, and are shown looking to left or right. The features are formalized, so that the onlooker is left in no doubt as to who is represented. At Amiens St Firmin is an imposing and stately bishop; and at Rheims St Elizabeth is an old woman with a resigned air, while the Virgin Mary radiates youthful beauty. Most female statues, especially of the Virgin, are particularly elongated; often, too, they have a curvilinear rhythm sometimes so pronounced that it forms an 'S' shape.

▼ ▶ Simon and a servant, two statues in the central Portal of the Madonna, on the west front of Rheims cathedral. The servant's weight is borne on one leg while the other is slightly to one side, allowing a curvilinear flow to the robes.

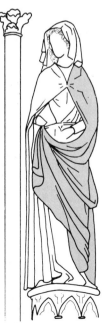

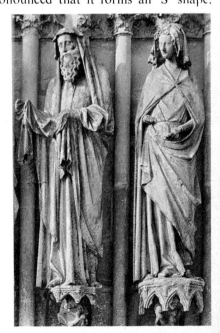

▶ Statue of an Old Testament fore-runner of Christ, from the Royal Portal of Chartres cathedral. It is representative of the earliest phase of Gothic sculpture. The figure is elongated and stands on a pedestal under a canopy. The arms are held close to the body and the folds of the robe are rigid parallel lines, cut shallowly, and reminiscent of the flutings of a column. The head takes up one-sixth of the body's length and conforms to the aesthetic canon of the period, with an expression of serenity which heightens the sanctity conveyed by the figure.

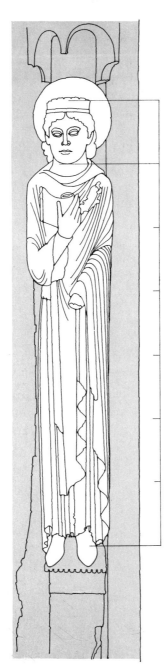

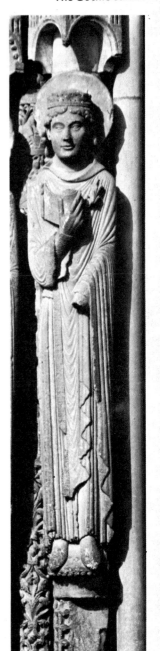

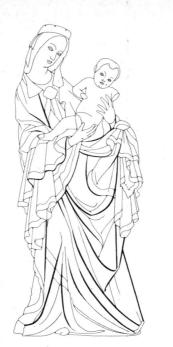

► The tension be-
tween the broken
lines, typical of
sculptures not in-
cluded in an archi-
tectural scheme,
stands out strongly
in this Madonna and
Child. At the same
time the composi-
tion almost appears
dissolved by the
grace and elegance
with which the drap-
eries are arranged.

► The beautiful
*Madonna of Kru-
mau*, from Bohemia,
a small sculpture
only 112cm in
height, and dating
from about 1390.
As was customary
for Gothic sculp-
tures, it was formerly
painted, and it still
bears traces of the
original colours.

which is emphasized by the arrangement of the draperies.

The theme of the Madonna was also a favourite one for the small statues produced by craftsmen for country churches and for the aristocracy and rich merchants. In addition to the Mother and Child the subject matter of these devotional images often included Christ and St John, with the disciple asleep on the breast of the Redeemer; the dead Christ lying in the arms of Mary; and the Crucifixion.

One especial number of sculptures depicting the Madonna and Child, created by Bohemian and German craftsmen, is outstanding for its grace, elegance of modelling, and splendid colouring. Of these *schoenen Madonnen* perhaps the finest is the *Madonna of Krumau*.

Gothic sculpture was always painted. Faces and hands were given a natural colour, and the hair was a golden yellow. Robes were brightly coloured and ornamented with jewels and clasps, and the borders of mantels were encrusted with precious stones or coloured glass. The impressive overall effect was intended to intimate a truly celestial vision.

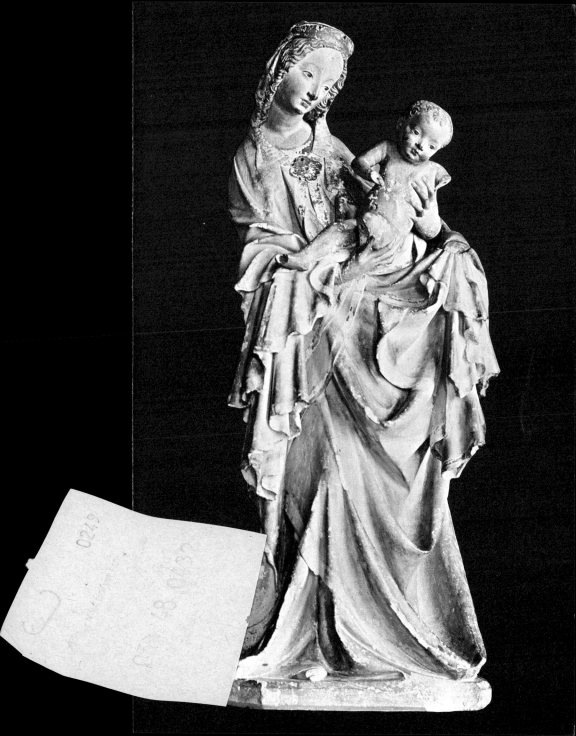

Applied Arts

▶ Stained glass in one of the windows of Chartres cathedral, showing episodes from the Life of Christ. The images are arranged in sequence, to read across from square to square.

▼ Typical features of Gothic stained-glass pictures included attention to detail, clear-cut outlines to the figures, and personally identifying gestures, like that of the Christ in the diagrams shown. The background was highly stylized and usually architectural, in the form of arches, or natural, as for example the sea.

The term 'applied arts' is used by historians and art critics to distinguish weaving and the making of stained glass, jewellery, and illuminated manuscripts from the major arts of architecture, sculpture, and painting. In some of these minor arts – making stained glass, for example – the Gothic achievements were never again to be equalled. There were both social and economic reasons for the flowering of these arts. During the later Middle Ages rich merchants vied in their life-style with the nobility, and their patronage of the arts stimulated craftsmen to excel in the production of jewellery, tapestries, small paintings, and illuminated manuscripts. These were all largely destined for private households, which allowed artists greater freedom of expression both in choice of subject and its execution than when their work had been commissioned exclusively by the clergy and nobility.

The extraordinarily advanced developments in the art of making stained glass were obviously due largely to its extensive use in the windows of the great Gothic cathedrals, where it created the illusion of almost dissolving the walls into something fantastic and impalpable. The stained glass was made up of small panes of coloured glass held together by strips of lead, which formed the outline of each figure. Facial features were

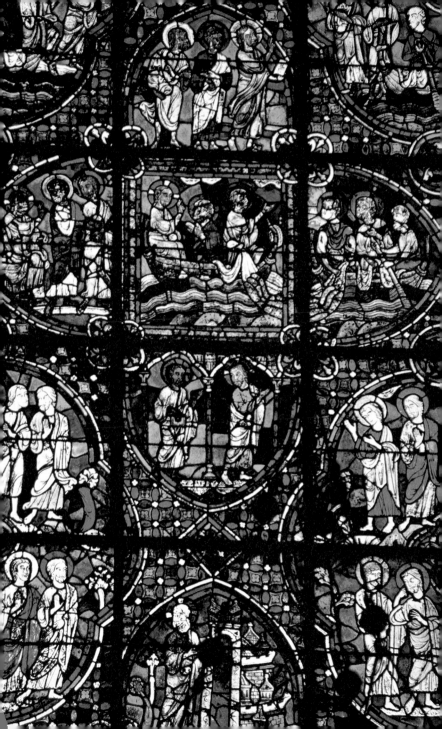

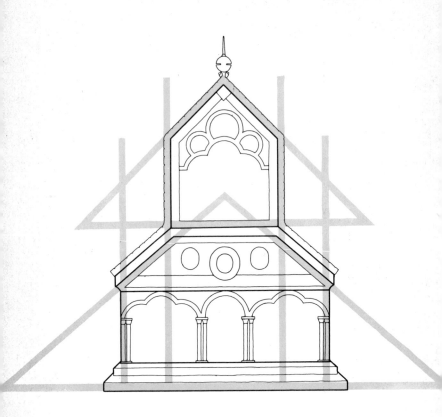

▲ Geometrical shapes — arcs, equilateral triangles, rectangles, polygons — fascinated Gothic artists. This reliquary is a replica of a Gothic basilica and is easily seen to be divided into a series of mainly triangular shapes.

delicately traced in black enamel paint, which was also used for other details within each figure, such as the clothing. The individual scenes making up a large window were contained in a framework which was often scallop-shaped. In each compartment there was a scene from the Old or New Testament, designed to instruct the faithful. Clarity was achieved by keeping the number of figures to the essential minimum. The figures themselves were elongated and two-dimensional; that is, they represented height and width but not depth. Expression was conveyed not so much by the face as by gestures which were as bold as possible to make each scene quite clear.

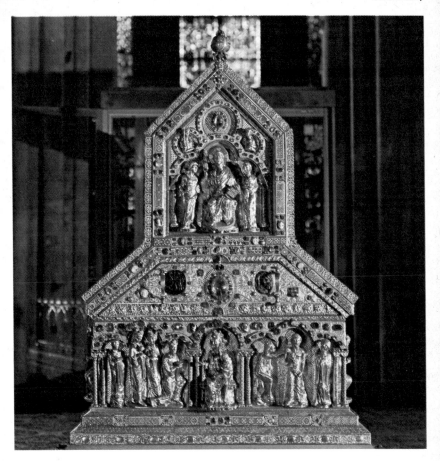

▲ The Shrine of the Three Kings, a reliquary by the goldsmith Nicholas of Verdun, completed about 1230. The shorter side, shown here, depicts the Adoration of the Magi and the Baptism of Christ in the lower part, while the upper part shows the Redeemer enthroned, with an angel on either side.

The backgrounds were also two-dimensional, with little indication of depth, a contemporary characteristic not only of stained glass but of all painting. Architectural features were usually suggested by pointed arches on small columns, and landscapes by stylized rocks and trees, while the sea was also very stylized, as a series of wavy lines. The draughtsmanship was extremely sophisticated and even the smallest details were executed with great precision. Despite the fact that these masterpieces were generally made to be seen only from a distance, in their delicacy and beauty they vied with the illuminated manuscripts of the time. The colours were usually bold reds, blues, greens, and yellows, all juxtaposed, with the

sense of colour harmony that makes Gothic stained glass 'shine with colour like precious stones'.

Equally prized was the jewellery made by the gold-smiths of the time, both for its quality of design and for the materials used. The development of this art cannot be explained solely by the love of luxury of kings, noblemen, burghers, and clergy. For medieval man the preciousness of the material symbolized the spiritual value of the object – and most jewellery of this period was destined for religious use. It included liturgical vessels – chalices and pyxes – reliquaries for the remains of saints, and monstrances. Gold and silver objects of this kind were the pride of many a cathedral or monastic treasury. Today these collections are largely dispersed, since they proved too great a temptation for the powerful of all periods, who competed to lay hands on them. Their artifacts were often encrusted with ornament such as pearls, precious stones, and rock crystal, and decorated with filigree work and enamel. The spires and flying

► In traditional Gothic style, the composition of this illumination is two-dimensional and features abstract motifs like a fabric, with a framework of stylized pillars. The most important person tended to be placed in the middle. The absence of perspective was so marked that the feet of the people de-picted sometimes overlapped. Never-theless the illu-minator was able to achieve narrative clarity by emphasiz-ing gestures and facial expressions.

buttresses, and the general emphasis on verticality, of Gothic architecture were a great influence on the creators of contemporary jewellery, and reliquaries and monstrances were often executed in the shape of miniature buildings. One of the best-known works of the period is a reliquary, the Shrine of the Three Kings, by Nicholas of Verdun. This container is made of oak in the shape of a basilica with a nave and two aisles, the nave being higher than the two aisles. The outer covering is of embossed silver gilt, and faithfully reproduces the exterior features of a cathedral. The longer sides are decorated with a series of arches resting on short pillars, like the arches of a nave, each containing the figure of an apostle, prophet, or king.

The art of the Gothic illuminators, like that of the makers of stained glass, has also remained unequalled in originality and excellence. Illuminations were painted on the parchment of manuscripts – printing had not yet been invented, or at any rate was still unknown outside

▶ Illumination from the *Chronicle of St Denis* showing Charlemagne in a legendary episode of his life, sending an embassy to the Queens of Saragossa. Though ornamental in their appearance, such secular illuminations did have a specific narrative function.

China. By the mid thirteenth century the most important centre of the art was Paris, and by the end of the Middle Ages the greatest artists of that city were Flemish. The development of illumination was stimulated by an increased distribution of illustrated manuscripts. Once these had been the exclusive property of the monasteries, but as in other branches of Gothic art, growing prosperity and cultural changes put them in demand with private patrons, both aristocrats and burghers. The illuminators were now called upon to decorate books which, though still large, were smaller and more manageable than the Bibles and Gospels – in other words, the 'pocket editions' of the period. These were psalters – collections of psalms – and books of hours – prayer books or missals for private use which indicated the services to be conducted at various hours of the day and night – and manuscripts of secular interest, such as poems of chivalry, tales, chronicles, and collections of songs.

The illuminations had both a decorative and narrative function. The ornamentation of capital letters at the opening of books or chapters was purely decorative, often developing into linear arabesques surrounding the

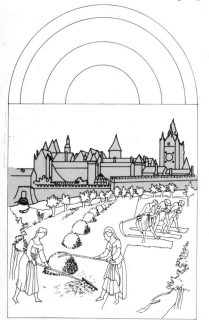

◀ ▶ The month of June: harvesting outside Paris, with the Palais de la Cité and the Sainte Chapelle in the background. This illumination is from the *Très Riches Heures* of the Duke of Berry, painted by the brothers Pol, Hannequin, and Herman of Limbourg around 1416. In this work great care has been taken over perspective and there are no longer plain motifs in the background. The city of Paris behind is as important as the harvesting figures in the foreground, and is executed with such precision that it could make a picture in its own right.

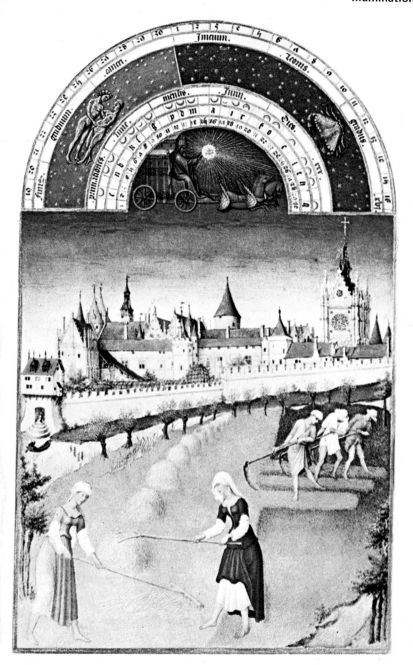

▶ The altar tapestry of the Order of the Golden Fleece, showing the mystical marriage of St Catherine. The Madonna, as the most important figure, is in the centre of the picture, and a geometrical arrangement of stylized arches frames the group.

entire page. Their motifs were usually taken from the plant and animal kingdoms, and showed stylized representations of flowers, birds, or insects. Other illuminations took up whole pages and directly illustrated the text by telling a story. Sometimes they were simply one picture, but sometimes they were a sequence of scenes filling the page. The individual scenes might be enclosed in four-lobed frames, giving the page the appearance of a stained-glass window, an effect reinforced by the brilliant colours. The style of the illuminations, again as on stained glass, was two-dimensional, and the elegant and richly clad figures, often painted on a gold ground, were drawn with minute precision. As with jewellery, the richness and variety of the illustrations and the splendid colours and abundance of gold were a sign, to the medieval mind, of the spiritual and religious value of the contents of the book. The subject of illuminations, however, was not always a religious one. The *Très Riches Heures*, the Book of Hours of the Duke of Berry,

▶ A central pattern of curves, balanced and harmonious, is formed from the folds in the Madonna's robes, gradually expanding towards the foreground.

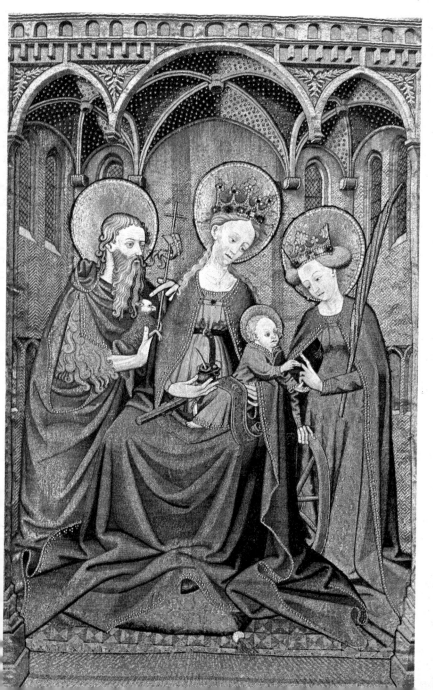

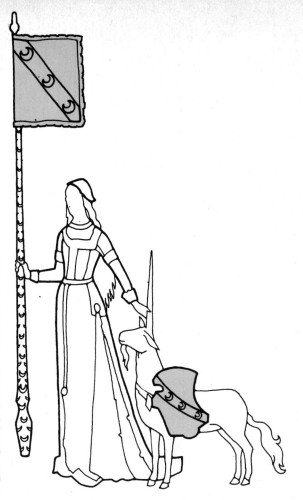

▶ The elongated figure of the Lady with the Unicorn, slender and aristocratic, conforms to the principles of Gothic art. The effect is enhanced by a series of vertical elements including the Unicorn's horn and the shaft of the banner, while the Lady's stiff posture offsets the curving lines of the animal. Both shield and banner carry the escutcheon of the La Vista family, who commissioned the tapestry.

contains a series of scenes representing in minute and compelling detail agricultural work, the various crafts, and other scenes of everyday life.

Tapestries also were widely used during this period. These large woven pictures very much appealed, as a domestic refinement, to the tastes of the nobility. They were used to decorate the bare walls of large rooms, or to subdivide rooms to create a more intimate atmosphere. Lay subjects were favoured and included chivalric episodes, amorous-adventures, hunting scenes, allegory, and legends.

The main centre of production for tapestries in the

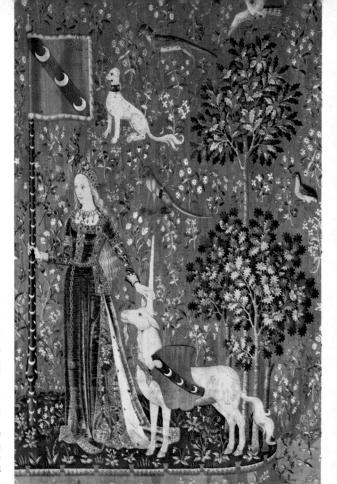

► One of the 'Lady with the Unicorn' tapestries, a series of six completed around 1500, which originally decorated a room in the Château de Boussac in Creuse. The use of colour is remarkable, the red background being in striking contrast with the intense blue of the foreground forming a small island on which the figures stand.

Middle Ages was at first Paris; in the fifteenth century, however, it was the craftsmen of the major cities of Flanders, notably Arras, Bruges, Tournai, and Brussels, that came to excel in this particular art. One of the most agreeable idioms of tapestries produced during this later period was the dark blue background, speckled with small colourful flowering plants, known as *menues verdures*, 'small verdures'; or *mille fleures*, 'thousand flowers'. Often, too, this type of tapestry included sumptuously dressed figures whose clothes, falling in ample, elegant folds, give a detailed idea of contemporary high fashion.

Painting

During the Gothic period painting did not, on the whole, play as fundamental a role as in many other periods of art history. Because there was so little solid, unbroken wall-space in the Gothic cathedrals, these did not lend themselves to painted decoration. The exception was to be found in Italy, where, since Gothic architecture never attained the soaring lines and lightness of the French, English, and German cathedrals, the taste for large-scale frescoes on religious subjects survived. But in churches throughout the rest of Europe the great narrative cycles ceased to be executed.

Painting was, however, widely used for secular purposes, as decoration for the rooms of castles, the houses of the gentry, and civic buildings. There was an economic reason for this, in that as wall-coverings frescoes were cheaper than tapestries. Popular subjects were tales of romance, scenes from courtly life, secular legends, and knightly feats of arms.

▶ Stephan Lochner's *The Adoration of the Child.* This small painting (36cm by 23cm), in tempera on wood, was executed during the first half of the fifteenth century. It was intended for use in private worship. Its fascination lies very much in its wholly Gothic character — in the work's simplicity; in its being on wood; in a love of detail as shown in the shepherds and their flock and the turreted town; and in the elegant posture of the Virgin, emphasized by her flowing mantle.

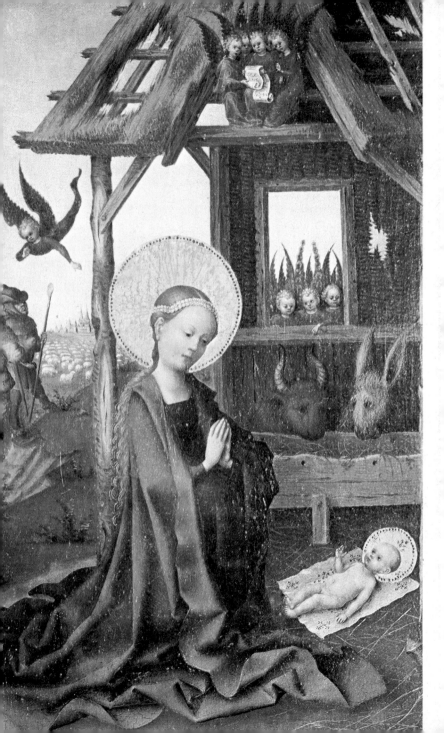

Traditional uses

▼ The carved arches of this *Annunciation* form a triptych — but without pillars to interrupt its continuity. In the centre, the lilies signify purity. The pensive figure of the Virgin is arranged in a subtle counterpoint of contrasting curves.

The style of devotional paintings also reflected that of tapestries in some ways, notably the frequent attention to small, intimate detail having no direct connection with the subject, as in the carefully rendered stones, flowers, and tufts of grass in the foreground of many paintings.

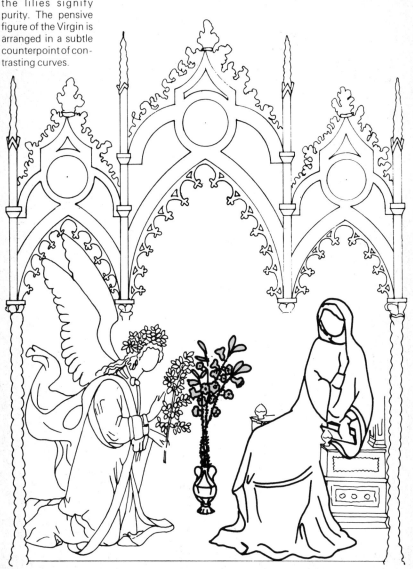

▼ *The Annunciation,* by Simone Martini. This remarkably large tempera on wood — it measures 265cm by 305cm — was painted in 1333 for the altar of the Chapel of St Ansano in the cathedral at Siena.

Other features typical of Gothic painting often included a presumably totally true-to-life vista in the background, in which peasants go about their daily work and a whole Flemish or Italian city stands amid a fragment of verdant medieval landscape.

Other forms of Gothic painting were usually done on wood. Nobles and rich burghers commissioned small paintings or portable altars for their private devotions, and for their churches the clergy had larger pieces executed. These were either displayed on an altarpiece, as a single panel, or as several hinged panels, known as a polyptych. Of the latter, which came to be the preferred

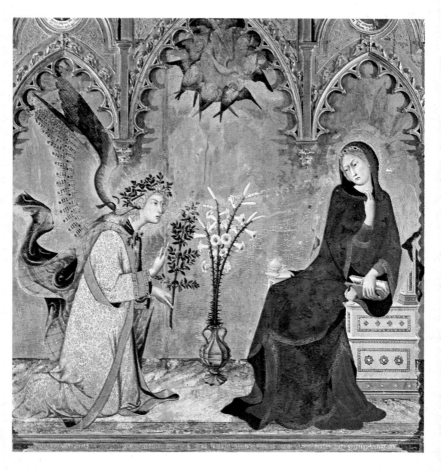

form, those with two panels were known as a diptych and those with three as a triptych. Each panel was framed by a pointed arch, sometimes with three lobes, resting on slender pillars and generally resembling a Gothic window. In its frequent use of pinnacles, steeples, and flower motifs, the ornamentation of the frame further recalls the architecture of the time.

As with illumination, Gothic painting paid great attention to detail while demonstrating little interest in perspective. A background of gold often surrounded the foreground figures, giving an other-worldly atmosphere and at the same time heightening the other colours. In depicting religious subjects Gothic painters were mainly concerned with rendering their mystic and divine aspects, and not with the realism imparted by spatial depth. The faces, especially those of women, are gentle, serene, and slightly stylized, as if following an ideal prototype. These figures exist in a world of grace, beauty, balance, and calm from which sin, pain, and the vulgarity of daily life have been eliminated. The Madonnas wear flowing robes which fall in ample and elegant folds, arranged in curves to give expression to the Gothic artists' love of geometry. Valiant and chaste knights wear shining armour, and prelates in splendid vestments kneel in ardent prayer. As a rule the figures were given a stylized architectural background; but sometimes a naturalistic element was introduced, in the form of rocks. trees. or flowers.

▶ Giotto di Bondone's *Crucifixion*, a work of the late thirteenth century executed in tempera on wood and measuring 578cm by 406cm. The body of Christ follows the curve which also takes in the reclining head; the arms form another, contrasting, curve. The innovative Giotto was not concerned with the Gothic canons of linear rhythms and purely aesthetic values. He renders the depth and plasticity of the human form and here brings out the suffering of Christ, paying great attention to anatomic detail and using chiaroscuro. His colours are more delicate than those customarily used by Gothic artists.

Master of Trebon

▶ The stylized background, of sloping rocks with small trees, is representative of contemporary styles, as is the slender verticality of the risen Christ, emphasized by the upright of the cross. Likewise typical is the motif of the erect figure of Christ dominating the painting from the centre, while his enemies, symbolizing the forces of evil, are relegated to positions on the periphery of the canvas. The unreal, slightly fantastic atmosphere is one of the essential features of Gothic painting.

There were important exceptions to the Gothic school of painting as described. One was Giotto, an innovator whose works, especially the *Crucifixion* in the church of Santa Maria Novella, in Florence, reveal a deep interest in the human figure. His people are not aristocratic and tranquil but express the joys and pains of real life. For him, expressiveness was of paramount importance. Another exception, particularly significant in its consequences, is represented by the Flemish school, which, from 1420, perfected the technique of oil painting, largely through the skills of the brothers Van Eyck, Jan and Hubert. This was a first step towards emancipating

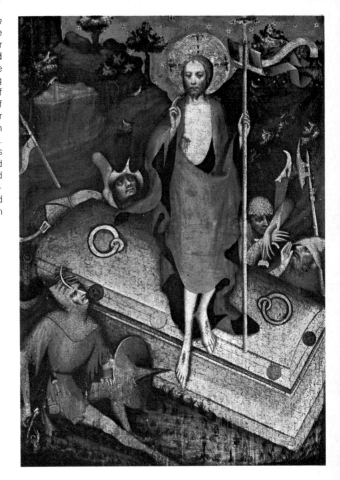

▶ *The Resurrection of Christ,* by the Master of Trebon or Wittingau, painted in 1390. This is one wing, measuring 132cm by 92cm, of the altarpiece of Wittingau after which the unknown painter is named. The composition is based on a bold harmony of reds and greens, its effect enhanced by the red sky with its golden stars.

painters from the influence and conventions of illumination, architectural structures, and sculpture.

There were also highly individual variations in the use of colour. In the work of the Master of Trebon or Wittingau the refined luminosity of the Gothic style was replaced by bold and imaginative harmonies of reds and greens. At the same time, however, that it departed from contemporary modes, it still maintained the dreamlike and unreal atmosphere common to the painters who excelled, in one form or another, during the centuries when throughout Europe the successive styles of Gothic art prevailed.

Glossary

Altarpiece: a painting or, less often, a sculpture in low relief, placed behind and over the altar. It sometimes consists of several panels, when it is called a polyptych; of these, paintings on two panels are known as a diptych, those with three, a triptych.

Ambulatory: a corridor or aisle between the choir and the apse.

Apse: a projection at the east end of a church; rarely, and in certain regions, it also occurs at the west end. It can be either semicircular or polygonal.

Barrel vault: *see* Vault.

Base: the lower part of a column or pillar.

Basilica: a church composed of a nave, and two or more aisles lower than the nave.

Capital: the upper part of a column or pillar, which broadens out to provide a stronger base for an arch.

Column: an architectural support element, cylindrical in form. (If square or rectangular it is called a pilaster.)

Cross vault: *see* Vault.

Decorated: style of English architecture widely used in the fourteenth century; characterized by features including lavish ornamentation.

Diptych: *see* Altarpiece.

Early and Middle English: styles of English Gothic architecture superseding Romanesque.

Embrasure: a bevelling inwards of the surrounds of a window or doorway, often richly decorated.

Flying buttress: an exterior arch or half-arch transmitting the thrust of a vault from the upper part of a wall to a vertical buttress, and thence into the ground.

Foil: space surrounded, in a window, by several adjacent arcs.

Keystone: the central stone of an arch or vault. It is often decorated.

Lights: the openings between the mullions dividing a window.

Missal: a prayerbook, often taken to mean an illuminated one.

Monstrance: a vessel in which the Host is displayed.

Mullion: a vertical upright, used to divide a window into two or more lights.

Nave: the main body or western part of a church; more usually, the middle section of this part, flanked by aisles.

Partition: *see* Web.

Perpendicular: a style of English architecture widely used in the fifteenth century and largely featuring narrow vertical shapes.

Pilaster: *see* Column.

Polyptych: *see* Altarpiece.

Portal: a decorated, monumental entrance to a church or other large building.

Pyx: a vessel used to hold consecrated bread.

Reliquary: container for a holy relic.

Rhomboid: a form commonly described as a diamond shape.

Tempera: a painting technique, formerly in common use, which consists in painting with colours mixed with an organic, glutinous substance – usually egg yolk. The word means any kind of binder which will serve to 'temper' powder colour and make it workable.

Transept: that part of a church with a plan in the form of a Latin cross which intersects with the nave. It is sometimes divided into aisles.

Triforium: a gallery above the aisles of a church, so called in Gothic churches because it usually opens on to the nave through arches each divided into three parts.

Triptych: *see* Altarpiece.

Trumeau: a pillar, or stone element, dividing an opening or doorway.

Tunnel vault: *see* Vault.

Tympanum: the area within the arch of a doorway, and above the lintel.

Vault: an arched roof or ceiling formed by the span of an arch or the intersection of two such spans. The most common medieval forms were the barrel, or tunnel, vault, consisting of a continuous vault of semicircular or pointed sections; and the cross, or groin, vault, formed by the intersection at right angles of two barrel vaults.

Web: in Gothic architecture, a compartment of a cross vault.

Bibliography

Branner, R., *Gothic architecture*, Prentice-Hall, 1964. The best short introduction to Gothic architecture.

Brieger, P., *English Art, 1216-1307*, Oxford University Press, 1957. All aspects, at a great period of achievement.

Dupont, J., and Gnudi, C., *Gothic Painting*, Zwemmer, 1954.

Evans, J., *English Art, 1307-1461*, Oxford University Press, 1949. The best book ever written on this fascinating period.

Evans, J., *Life in mediaeval France*, Phaidon, third edition 1969. A bestseller since 1925.

Frankl, P., *Gothic Architecture*, Penguin Books, 1963. Idiosyncratic, but the standard work.

Huizinga, J., *The Waning of the Middle Ages*, E. Arnold, 1955. The classic work.

Kidson, P., *The Mediaeval World*, Hamlyn, 1967. Best short introduction to the period.

Martindale, A., *Gothic Art*, Thames and Hudson, 1967. Best short introduction to the Gothic.

Swaan, W., *The Gothic Cathedral*, Elek, 1969. Excellent photographs, and C. Brooke's valuable 'The Cathedral in Medieval Society'.

Swaan, W., *The Late Middle Ages*, Elek, 1977. Excellent illustrations.

Sources

Alte Pinakothek, Munich: 54; Cluny Museum, Paris: 53; Cologne cathedral treasury: 45; Condé Museum, Chantilly: 48; Kunsthistorisches Museum, Vienna: 41, 50; National Gallery, Prague: 61; Santa Maria Novella, Florence: 58; Uffizi Gallery, Florence: 57

Index

y

Photocredits

Almasy: 33; Cauchetier: 4, 5, 8, 9, 11, 25,
27, 29, 31, 39; Giraudon: 47; Hassmann:
19, 21, 23, 45; Kunsthistorisches Museum,
Vienna: 41; National Gallery, Prague: 61;
Photo Marburg: 53; Pubbliaerfoto: 37;
Radnicky: 17; Rizzoli: 34/35, 38, 49, 51,
55, 57; Scala: 15, 59; Sheridan: 7, 12, 13,
43